DENVER ART MUSEUM

HIGHLIGHTS FROM THE COLLECTION

Denver Art Museum

In association with Scala Publishers

SCALA

First published in 2006 by
Scala Publishers Limited
Northburgh House
10 Northburgh Street
London EC1V 0AT
United Kingdom

Distributed outside the Denver Art Museum
in the booktrade by
Antique Collectors' Club Limited
Eastworks
116 Pleasant Street, Suite #60B
Easthampton, MA 01027
United States of America

ISBN: 1-85759-432-0

Library of Congress Control Number: 2006903052

Edited and Compiled by Laura Caruso
Director of Publications, DAM: Suzanna K. Moran, Esq.
Designer, DAM: Shar Huston
Project Manager, Scala: Sally Fisher
Designer, Scala: Pooja Bakri
Editorial Director, Scala: Oliver Craske
Production Director, Scala: Tim Clarke
Printed in China
10 9 8 7 6 5 4 3 2 1

Special thanks to the curatorial, education, and
publications staff at the Denver Art Museum and to
Allison Melun for additional project management
and editorial assistance. Photographs were supplied by,
and permissions secured by, Carole Lee Vowell and her
staff in the Photographic Services and Image Rights
Department: Kevin Hester, Bill O'Connor, Lloyd Rule,
Eric Stephenson, and Jeff Wells.

Front Cover Illustration: detail, see p.15.
Title Page Illustration: Photo by Jeff Wells.

Some of the text in this book has appeared previously
in other forms in the following publications:

*Pre-Columbian Art in the Denver Art Museum
Collection*, by Margaret Young-Sánchez. Published
by the Denver Art Museum, 2003.

*Sweet on the West: How Candy Built a Colorado
Treasure*. Published by the Institute of Western
American Art at the Denver Art Museum in
association with the University of Washington
Press as part of the *Western Passages* series, 2003.

USDesign 1975–2000. Published by Prestel
Verlag, 2001.

*Painters and the American West: The Anschutz
Collection*, by Joan Carpenter Troccoli. Published
by the Denver Art Museum and Yale University
Press, 2000.

The Denver Art Museum: The First Hundred Years,
essays by Neil Harris, Marlene Chambers, and
Lewis Wingfield Story. Published by the Denver
Art Museum, 1996.

The View from Denver. Published by the Museum
moderner Kunst Stiftung Ludwig Wien, 1997.

Table of Contents

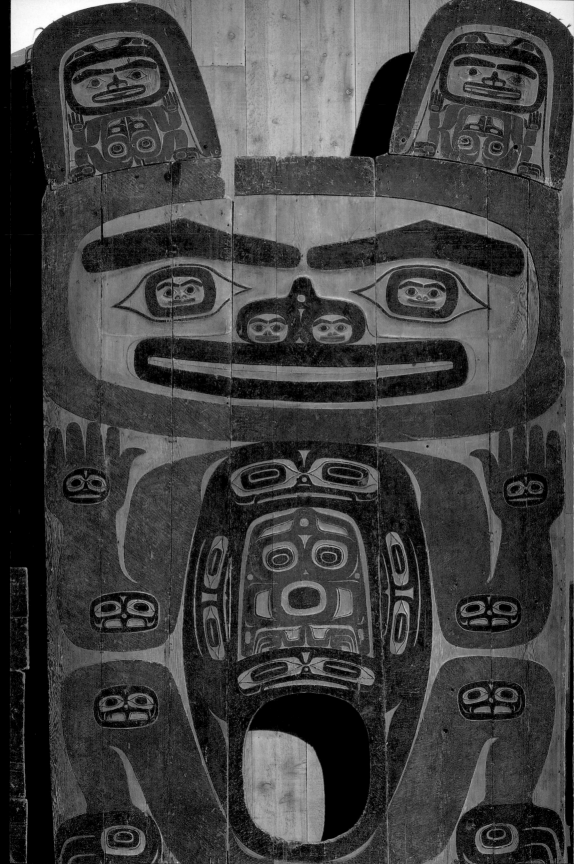

Preface

The Denver Art Museum long predates the complex in which it is now housed. Since its beginnings in the 1890s as the Denver Artists' Club, the museum has had a number of temporary homes, from the public library and a downtown mansion to a portion of the Denver City and County Building. The opening in 1971 of what is now called the North Building, designed by Gio Ponti and Denver-based James Sudler Associates, ushered in a new era of stability and growth that culminated in the 2006 opening of the spectacular Frederic C. Hamilton Building, designed by Daniel Libeskind and Denver-based Davis Partnership Architects. Today the museum occupies more than 362,000 square feet in the heart of one of the most vibrant cities in the country. Its holdings exceed 60,000 objects, which represent almost all major periods and cultures in the history of art.

But great art and outstanding architecture do not constitute a successful museum experience. To paraphrase the artist Marcel Duchamp: "The work of art is not performed by the artist alone. The viewer completes the art." The visitor's experience is of primary importance at the Denver Art Museum. Our innovative gallery installations and education programs are intended to help visitors of all ages forge meaningful connections with the art on display.

Whether you are visiting for the first time or the tenth, I am confident you will find something to delight, provoke, and amaze you. The objects illustrated in this book are some of our most treasured artworks, but they are only a tiny sampling of what the galleries have to offer and are no substitute for being in the presence of the real thing. We hope that this book will whet your appetite, help you make your way through the galleries, and serve as a pleasant reminder of your visit.

Lewis I. Sharp
Director

House partition depicting an abstract bear figure—the Shakes family crest (detail), Tlingit, about 1840, Wrangell, Alaska. Cedar, paint, and hair, 180" h x 108" w.

General Information

This guide provides a brief introduction to the Denver Art Museum and some of its greatest treasures. The Denver Art Museum complex consists of the Frederic C. Hamilton Building and the North Building. This guide first covers the collections in the Hamilton Building—where most visitors enter the museum—and proceeds from the first floor to the top floor, then covers the collections in the North Building from bottom to top. Of course, you are free to explore the museum in any way you'd like. Just remember that the connection between the two buildings is on the second floor.

HAMILTON BUILDING

Lower Level	Auditorium
First Floor	Welcome Center, information, coat check, lockers, Museum Shop, temporary exhibitions
Second Floor	Western American art, connection to North Building, temporary exhibitions
Third Floor	Impressionism, modern and contemporary art, African art, outdoor sculpture deck
Fourth Floor	Modern and contemporary art, Oceanic art

NORTH BUILDING

Lower level	Classrooms and lecture room, Just for Fun Family Center, concourse to Denver Public Library
First Floor	Welcome Center, James Turrell installation, modern and contemporary photography, Schlessman Hall, Palettes restaurant, satellite Museum Shop
Second Floor	Northwest Coast Indian art, design after 1900, Duncan Pavilion, outdoor sculpture deck
Third Floor	American Indian art
Fourth Floor	Pre-Columbian art, Spanish colonial art, Southwest American art
Fifth Floor	Asian art
Sixth Floor	European & American painting and sculpture, design before 1900, Discovery Library, textile art

THINGS TO KEEP IN MIND

Objects pictured in the guide may not be on display during your visit. Galleries may be closed for reinstallation, or individual objects may be on loan to another institution or temporarily removed for cleaning and conservation. Some objects, like photographs, textiles, and works on paper, are rotated off display about every six months because too much light will fade them. One of our most popular works of art, *Linda*, is only on view for a few weeks each year because it's made of polyvinyl, a kind of plastic that breaks down chemically over time. Little can be done to stabilize the polyvinyl, so *Linda* spends most of her time off view in a controlled environment.

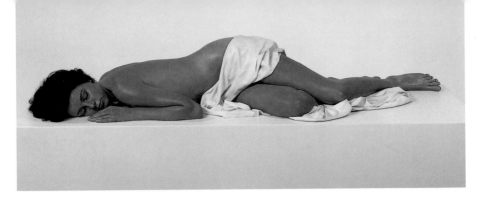

Linda, 1983, John DeAndrea (American, born 1941). Oil on polyvinyl, 10¾" h x 67" l.

A NOTE ABOUT THE ARCHITECTURE

The Frederic C. Hamilton Building is Daniel Libeskind's first completed building in North America. Libeskind, the master planner for the new World Trade Center in New York City, has also designed the Jewish Museum in Berlin and the Imperial War Museum North in Manchester, England. The North Building was designed by the famed architect Gio Ponti of Milan in association with James Sudler Associates of Denver. It opened in 1971.

Ask at the Welcome Center about tours and other ways to experience the museum's unique architecture. *Art Spaces*, a compact book that gives an insider's view of the design of the Denver Art Museum expansion, is available at the Museum Shop for $7.95. Orders can be made by phone.

CONTACT US

Denver Art Museum
100 W. 14th Ave. Pkwy.
Denver, CO 80204

Hours, admission prices, directions, current exhibitions, special events, classes, tours, education, and general information
720-865-5000 or
www.denverartmuseum.org

Membership
720-913-0130

Volunteer opportunities
720-865-5045

TDD/TTY
720-865-5003

Museum Shop
720-865-5035

GETTING HERE

The museum is located in downtown Denver between Broadway and Bannock at Thirteenth Avenue. The most convenient parking is in the garage on the west side of Broadway between Thirteenth and Twelfth. There are also parking lots to the south and west and metered parking on nearby streets.

Western American Art

With this painting, Charles Deas established the mountain man, with his independent life in the wilderness, as a truly iconic American character. In a pose reminiscent of the traditional equestrian portrait of a hero, the mountain man turns in his saddle to look behind him. Although this fellow may hardly seem a hero, dressed as he is in the worn garb of a trapper and with his chapped red face and droopy horse, he was a hero in the national view. The trapper may even be a sort of self-portrait. Although Long Jakes and Deas do not share similar features, Deas was known for dressing in an eccentric, archaic style.

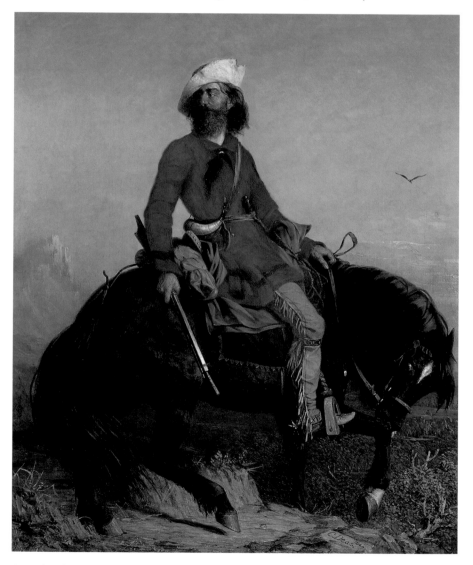

Long Jakes, The Rocky Mountain Man, 1844, Charles Deas (American, 1818–67). Oil on canvas, 30" h x 25" w.

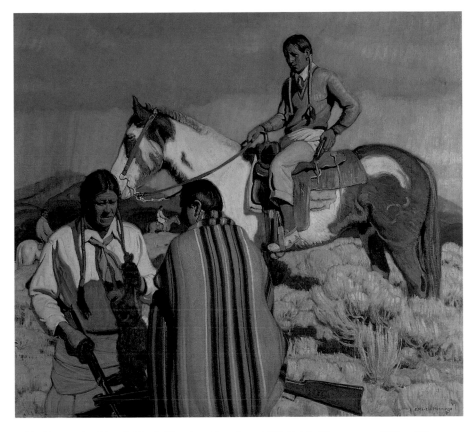

Rabbit Hunt, early 1920s, E. Martin Hennings (American, 1886–1956). Oil on canvas, 36" h x 40" w.

Like other classically trained artists who came West, Ernest Martin Hennings used his academic training to depict a newly discovered subject in American art—the land and people of New Mexico. Born in New Jersey, he graduated from the Art Institute of Chicago and later studied at the Royal Academy in Munich, Germany. In 1921 he settled in Taos. There he adopted a sunny palette reflective of the locale and produced paintings that feature an art nouveau decorative elegance while focusing on an ordinary moment, such as the rabbit hunt here. Just as the scene is very specific, so too are the Indians, who are treated as individuals and not stereotypes. The man on horseback sports a cross-cultural outfit: a tennis sweater, cuffed shirt, and trousers combined with traditional long braids and moccasins.

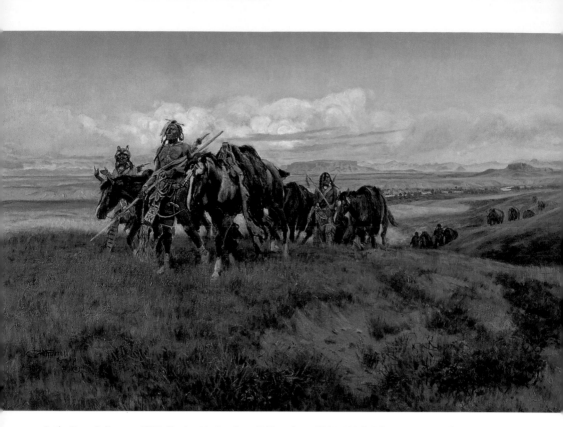

In the Enemy's Country, 1921, Charles Marion Russell (American, 1864–1926). Oil on canvas, 24" h x 36" w.

In the Enemy's Country is an important work, painted just five years before the artist's death. Russell himself acknowledged that he was capturing "The West that Has Passed," a romantic representation of native life before Europeans arrived. He portrays a party of Northern Plains Indians on a scouting mission in another tribe's territory. The setting sun spreads a quilt of color behind them as they advance alongside their horses. Their wariness—embodied in every aspect of their poses and expressions—heightens the sense of drama. The painting's idealized narrative reflects Russell's firm belief in the desirability of a life lived in harmony with nature.

Frederic Remington was already well known as an illustrator and painter when he turned his hand to sculpting in the mid-1890s. His first effort, *The Broncho Buster* (1895), became one of the most popular American bronzes. But *The Cheyenne* (1901), with its extraordinary action and unconventional treatment of equestrian subject matter, may well be the finest bronze he ever produced. Remington long admired the Cheyenne people and frequently favored them in his art. This one he portrayed "burning the air," as he said, in the midst of battle.

DAM FACT: The Continuing West

At the Denver Art Museum, "western" art doesn't end with Russell and Remington. At any given time, the western American art galleries might feature a red metal horse made by the Montana sculptor Deborah Butterfield in 1988 or photographs of Colorado taken in the 1970s by Robert Adams. And thanks largely to funding from its Contemporary Realism Group, the museum is actively collecting artwork being made today that deals with western subject matter.

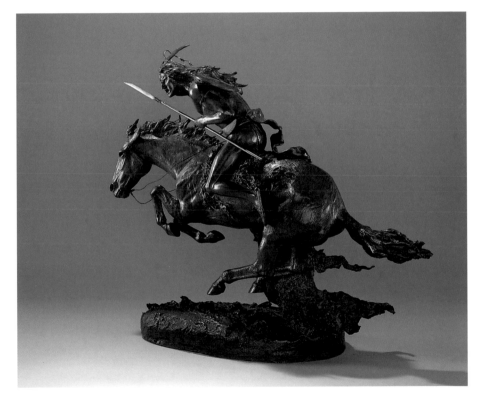

The Cheyenne, 1901, Frederic Remington (American, 1861–1909). Bronze, 21" h.

Eagle's Nest Lake, about 1935–37, Ernest L. Blumenschein (American, 1874–1960). Oil on canvas, 30" h x 40" w.

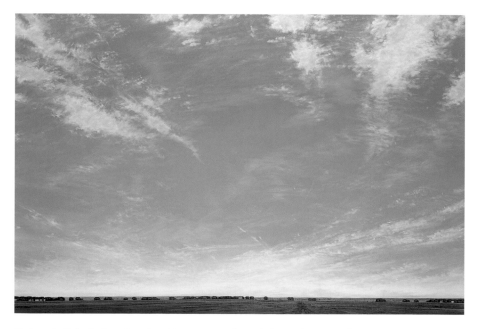

By June the Light Begins to Breathe, 1999–2000, Keith Jacobshagen (American, born 1941). Oil on canvas, 39¾" h x 60¼" w.

American Grasslands, 1997, Karen E. Kitchel (American, born 1957). Oil on wood, 12" h x 12" w each (twenty in series).

Although artists working in the West have painted all kinds of subjects—portraits, scenes of everyday life, and even still lifes—the West's magnificent scenery has always exerted a strong pull on painters. On these two pages, three twentieth-century painters respond to the land around them.

Ernest Blumenschein was one of the most prominent and innovative members of the Taos Society of Artists, which was active between 1915 and 1927. He was well up on the latest trends in European modernist art and incorporated these elements into his work. Although his painting is realistic, every feature in the landscape is reduced to its essential form, and the overall effect is one of rich pattern and color.

Keith Jacobshagen is a keen observer of the prairie that surrounds his home in Lincoln, Nebraska. But his use of extremely low horizon lines fills his canvases with sky and adds an emotional dimension to his work. "There are times when I read the paintings in the most practical way and I believe that they are simply about seeing the light falling across a space in the landscape in the late afternoon," he says. But, he admits, "I also hope that the images go a step further into some kind of spiritual realm."

Karen Kitchel's *American Grasslands* is composed of twenty 12" x 12" panels that depict, in close-up detail, different kinds of grasses, from lawns to pastures to prairies. "The series reflects how I have been approaching landscape for the last several years," the artist says. "Perhaps it also mirrors our national attitude toward the land at this point in time. My paintings are fragmented, mournful, and isolated, yet also well-preserved, perfectly ideal specimens."

Impressionism: A Sampler

Impressionist paintings are among the museum's most loved objects. To supplement its own collection (a sampling of which is shown here), the Denver Art Museum has collaborated with the Seattle Art Museum and the High Museum of Art in Atlanta to present exhibitions of impressionist art. *Impressionism: Paintings Collected by European Museums* visited Atlanta, Denver, and Seattle in 1999, and a new exhibition on impressionism and the art of the past, which features not only impressionist paintings but works by earlier painters including Diego Velázquez, Jean-Honoré Fragonard, and Claude Lorrain, visits the same three cities in 2007 and 2008.

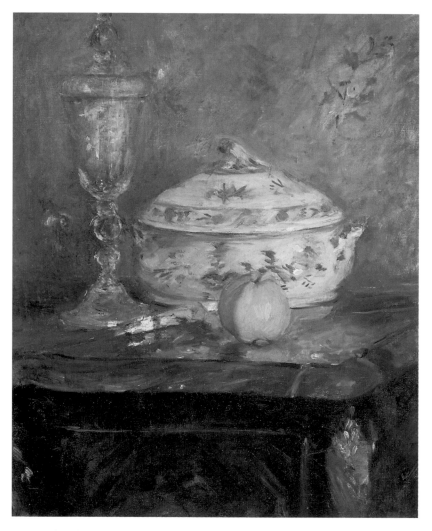

Tureen and Apple, 1877, Berthe Morisot (French, 1841–95). Oil on canvas, 22¼" h x 18¼" w.

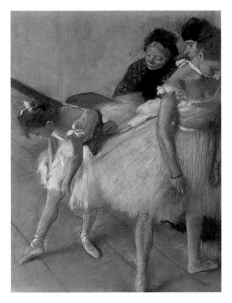

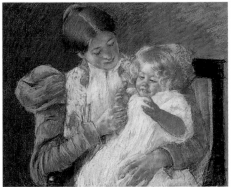

Patty Cake (Mother and Child), 1897, Mary Cassatt (American, 1844–1926). Pastel on paper, 23¾" h x 28¼" w.

The Dance Examination, 1880, Edgar Degas (French, 1834–1917). Pastel on paper, 24½" h x 18" w.

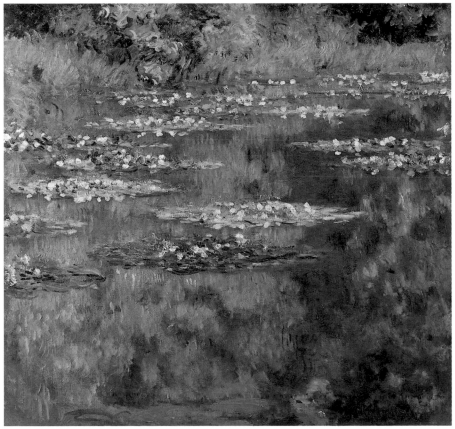

The Water Lily Pond, 1904, Claude Monet (French, 1840–1926). Oil on canvas, 34¾" h x 36" w. © 2006 Artists Rights Society (ARS), New York/ADAGP, Paris.

Modern & Contemporary Art

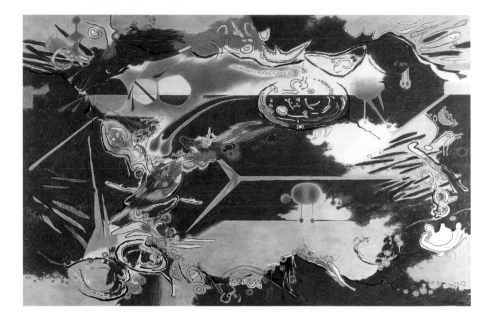

far back in time, 1954, Herbert Bayer (American, born in Austria, 1900–1985). Oil on canvas, 78¼" h x 119¾" w. © 2006 Artists Rights Society (ARS), New York / VG Bild-Kunst, Bonn.

Born in Austria in 1900, Herbert Bayer came to artistic maturity at the Bauhaus in Germany, where the emphasis was on integrated design that broke down boundaries between so-called "fine" and "applied" art. After brief periods in Berlin and New York, Bayer settled in Aspen, Colorado, in 1946 and made his home there until the mid-1970s. A prodigiously talented and productive artist and designer, Bayer (along with his wife, Joella) gave the museum the largest public collection of his work anywhere—photographs, posters, paintings, and sculptures, as well as examples of graphic design, typography, environmental design, and more. The Herbert Bayer Collection and Archive now numbers around 8,000 works plus documentary materials. Although Bayer is well known for his achievements in design, he called painting "the continuous link connecting the various facets of my work." Throughout his career he moved between highly structured, Bauhaus-inspired styles and freely expressive styles founded in nature and the cosmos, like the painting here.

In the early 1900s, Man Ray began experimenting with lensless photographic methods and pioneered the photogram (he called it the "rayograph," after himself), whereby an object placed directly on unexposed photographic paper creates a photographic image when exposed to light. In this 1943 example, he uses strong contrasts and abstract patterns of shadowy gray tones to achieve a dramatic three-dimensional effect.

Untitled, 1943, Man Ray (American, 1890–1977). Rayograph, 14" h x 11" w. © 2006 Man Ray Trust/Artists Rights Society (ARS), NY/ADAGP, Paris.

DAM FACT: Art & Technology

Rapidly changing technology has made collecting and displaying contemporary art a challenge. Many videos and other technology-based works can only be exhibited a few at a time because they occupy a large area or require a darkened or isolated space—like the Lorna Simpson DVD installation here, which is twelve feet across and features a soundtrack of fifteen people separately humming the song "Easy to Remember."

Easy to Remember, 2001, Lorna Simpson (American, born 1960). 16 mm film transferred to DVD, 108" h x 144" w.

Untitled (for A.C.), 1992, Dan Flavin (American, 1933–96). Fluorescent lights and fixtures, 96" h x 96" w x 9" d. © 2006 Estate of Dan Flavin/Artists Rights Society (ARS), New York.

Dan Flavin was one of the first artists to use light itself as a medium. Flavin took a "non-art" approach that favored industrial materials (in this case, off-the-shelf fluorescent tubes, electrical hardware, and an eight-foot-square steel armature). When not plugged in, the arrangement is unremarkable; illuminated, the sculpture transforms everything within its reach and seems to flatten the corner behind it into a single surface, half vibrant green and half rich blue.

Early in his career, Piet Mondrian departed from cubism to develop a completely nonrepresentational style that he called "neoplasticism." The series of paintings produced between 1929 and 1932 is the simplest statement of this style, which emphasizes the tensions and balances between a limited set of visual elements arranged on a two-dimensional plane. Each painting varies in its configuration of horizontal and vertical components and in the relationship of the three primary colors—red, yellow, and blue—plus black and white.

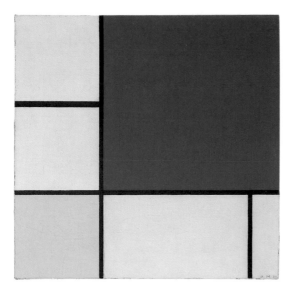

Blue, White, and Yellow, 1932,
Piet Mondrian (Dutch, 1872–1944).
Oil on canvas, 17⅞" h x 17⅞" w.
© 2006 Mondrian/Holtzman Trust
c/o hcr@hcrinternational.com.

Critically acclaimed as an abstract expressionist painter, Philip Guston shocked the art world in 1968 when he shifted to a figurative, "cartoonlike" style. *Blue Water*—which, at ten feet across, is one of his largest paintings—is a masterpiece of his later years. It contains some of the images that Guston referred to as his "new alphabet": shoe soles, hooded figures, cigarettes, buildings, books, and a head with a single eye. These images recur in Guston's work, but Guston refused to assign them any specific meaning.

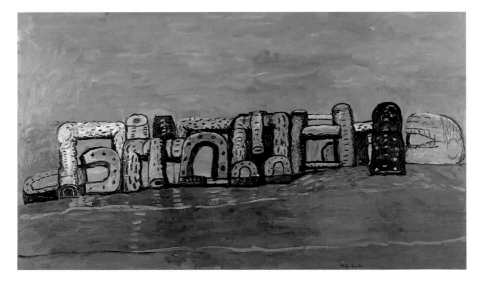

Blue Water, 1976, Philip Guston (American, 1913–80). Oil on canvas, 67¼" h x 117⅛" w.

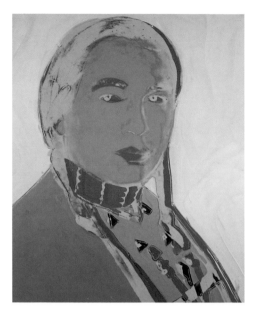

The American Indian (Russell Means), 1976,
Andy Warhol (American, 1928–87). Synthetic
polymer paint and silkscreen on canvas,
84¼" h x 70¼" w. ©2006 Andy Warhol
Foundation for the Visual Arts/ARS, New York.

In the 1960s, Andy Warhol's multiple images of soup cans, Brillo boxes, Marilyn Monroe, and Mao Tse Tung revolutionized the idea of art. *The American Indian (Russell Means)* is a rare exception in Warhol's work, for it comes closer to a traditional portrait painting than most of the artist's other work. Warhol asked the American Indian activist to sit for him after the two met at a gallery opening. Warhol photographed Means, screened the photograph onto several canvases, and overpainted each image using different colors. The work at the Denver Art Museum is the largest of the known canvases and the only one with a palette limited to black, gray, silver, and white.

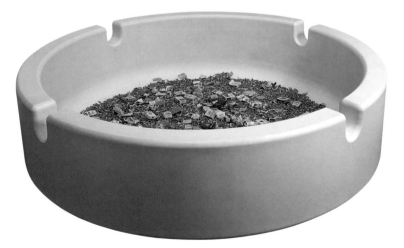

Party Time, 1995, Damien Hirst (British, born 1965).
Plastic resin, foam, and ashtray contents, 32" h x 96" d.

Damien Hirst's installations are calculated to shock. *Party Time*, a low, white sculpture in the shape of a gigantic ashtray, contains thousands of actual snuffed-out cigarette butts and prompts questions about smoking and its consequences. Its artistic predecessor is Marcel Duchamp's *Fountain*, a porcelain urinal that the artist signed and submitted to a gallery exhibition; *Party Time*'s imagery and scale also refer to Claes Oldenburg's oversized lipstick tubes and clothespins and especially his *Giant Fagends*, an eight-foot-tall foam sculpture of crushed cigarettes lying on a white plinth.

In 1994, the Denver Art Museum acquired twenty paintings, drawings, and collages from Robert Motherwell's estate. A leading abstract expressionist painter, Motherwell retained much of his work so that, after his death, important regional museums could purchase significant objects at a fraction of their appraised value. The magnificent painting seen here is the last of Motherwell's elegies to the Spanish Republic, a series he began in 1948. "The Spanish Civil War was even more to my generation than Vietnam was to be thirty years later to its generation," Motherwell wrote. "The *Spanish Elegies* . . . are my private insistence that a terrible death happened that should not be forgot."

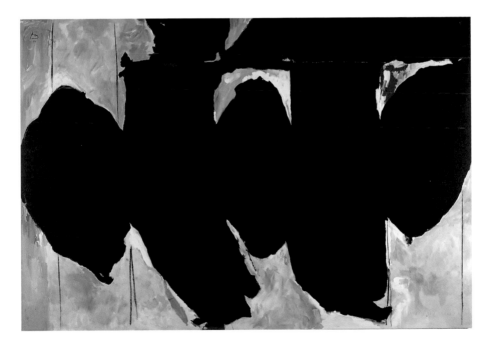

Elegy to the Spanish Republic #172 (with Blood), 1989–90, Robert Motherwell (American, 1915–91). Oil on canvas, 84" h x 120" w. © 2006 Dedalus Foundation, Inc./Licensed by VAGA, New York.

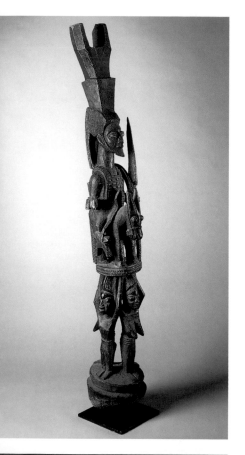

A virtuoso carver, Olowe Ise was known for his technically daring high-relief style and energetic compositions. Kings and wealthy patrons commissioned him to create veranda posts and doors to add beauty and prestige to their homes. The post seen here stands over five feet tall and depicts a warrior seated on a horse, supported by two women and two men. The warrior is deliberately carved to be larger than his horse to indicate his prominence. The placement of male and female figures beneath and supporting the warrior indicates the sharing of power between the genders that forms the foundation of Yoruba society.

Housepost, late 1920s, Olowe Ise (Yoruba culture, Nigeria, 1873–1938). Wood, 69" h.

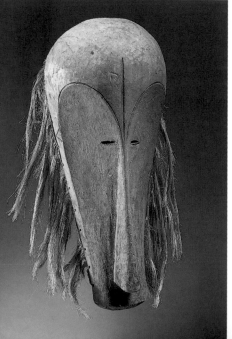

Very little is known about the purpose of the Fang *ngil* mask. The secret society that made this mask was banned in 1910 by French colonial rule, and knowledge about the mask was lost as a result. Its last known function was to cleanse the community of sorcery and other forms of evil. One meaning of the word *ngil* is "gorilla," and the arched eyebrows and broad, rounded forehead may be meant to model the prominent brow of the gorilla. The white color represents purity and the power of regeneration associated with ancestral forces.

Ngil mask, late 1800s, Fang culture, Gabon. Wood, paint, and fiber, 22" h.

The contemporary Yoruba artist Moyo Ogundipe draws on a vast storehouse of African and Western imagery for his paintings. Among his inspirations are the houseposts carved by Olowe Ise, such as the one shown on the opposite page. Traditional African body decoration, birds as symbols of freedom and power, and batik patterns are recurring motifs, but so are creatures from Greek mythology. Born in Nigeria, Ogundipe now lives in Colorado.

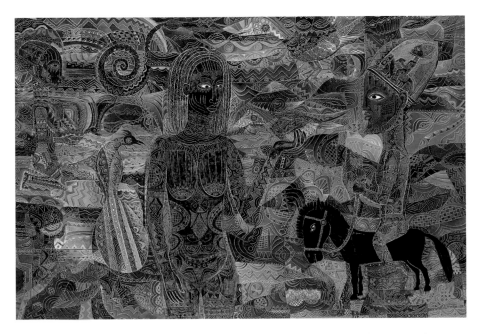

Soliloquy: Life's Fragile Fictions, 1997, Moyo Ogundipe (Yoruba culture, Nigeria, born 1948). Acrylic on canvas, 48¼" h x 72" w.

DAM FACT: A Gallery without Walls

The sloping walls of the DAM's new gallery for African art posed a challenge that the museum quickly turned to its advantage. Using the idea of a crossroads, the installation team pulled objects away from the walls and placed them on a series of platforms of varying heights that create a dynamic environment for a visitor to walk through.

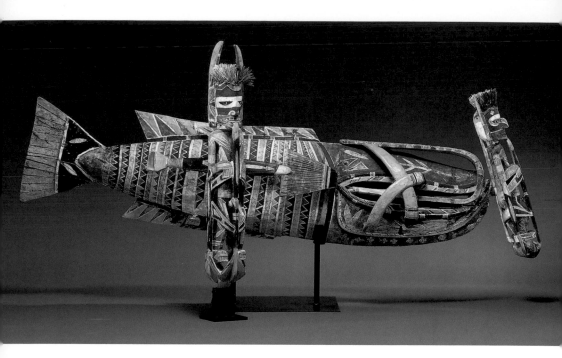

Malagan fish figure, date unknown, New Ireland, Papua New Guinea. Wood, paint, fiber, and shell, 41" h x 88" l.

The Denver Art Museum contains excellent examples of Oceanic art, with particular strength in Polynesian and Melanesian works. It is one of very few museums to display contemporary Oceanic art alongside historic objects. This fish sculpture was made by an unknown artist on the island of New Ireland, Papua New Guinea, for use in an indigenous Malagan ceremony. The entire surface is covered with brilliantly colored geometric designs that serve to unify the three parts of the composition: the central fish and the two male human figures attached to its side and snout. The fish is carved from a single piece of wood; open projections form its mouth and dorsal fins.

The tall, carved figure is from the Korewori River region of New Guinea. The artist has simplified the human figure into a series of projecting, hooklike shapes. The head features a beard terminating in a sharp point. Above the head, a cap with a comblike tassel curves forward to protect the entire sculptural framework. In the torso area, semicircular shapes carved in concentric patterns surround and protect a jagged phallic projection. The figure, carved from a single piece of wood, is probably an abstract representation of a hunting spirit.

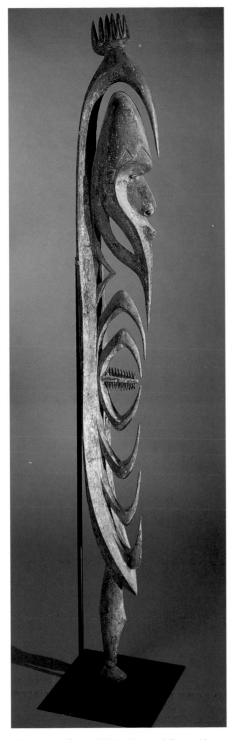

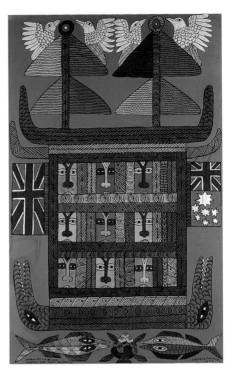

Dispela Em Sid Bilong Kiapten Kuk Ikam Austrelia ("This is the Ship Belonging to Captain Cook When He Came to Australia"), 1999, Mathias Kauage (Papua New Guinea, 1944–2003). Acrylic on canvas, 64½" h x 43" w.

Mathias Kauage is regarded as the most famous and influential contemporary artist in Papua New Guinea. His painting celebrates the historic contribution of Captain Cook, the British explorer who opened the South Pacific and its cultures to the international community. Kauage places his symbolic portrait of Cook and his entourage in the center of the composition. The vessel that carries him flies both a British and an Australian flag, and four birds top its colorful sails.

Yipwon spirit figure, 1800s, Korewori, Papua New Guinea. Wood, paint, and cowrie shells, 94¾" h.

Design After 1900

The chair is perhaps the quintessential design object of the last hundred years, because its form allows tremendous possibilities for experimentation with innovative materials (including steel, plywood, plastic, and polyurethane) and technologies (such as lamination, molding, and injection). These two pages feature a sampling of iconic chairs made between 1900 and 1960 by Frank Lloyd Wright, Ludwig Mies van der Rohe, Charles and Ray Eames, and Eero Saarinen.

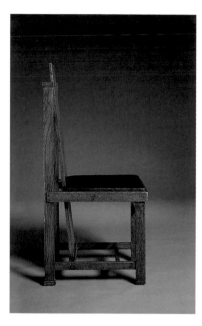

"Larkin" side chair, about 1904, Frank Lloyd Wright (American, 1867–1959). Oak and new leather, 40¼" h x 13¾" w x 18¾" d.

"MR" side chair, about 1927, Ludwig Mies van der Rohe (American, born in Germany, 1886–1969). Mfr: Thonet. Chrome-plated steel and new upholstery, 30½" h x 18½" w x 29" d.

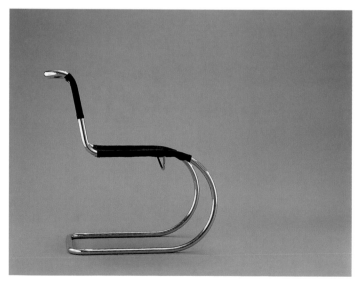

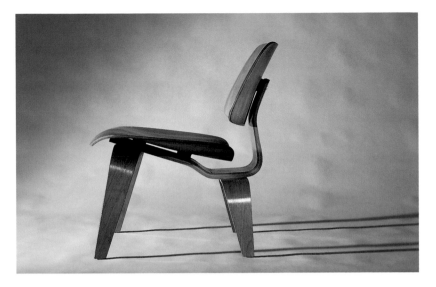

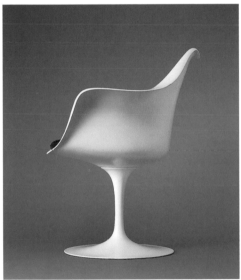

"LCW" lounge chair, 1946, Charles
and Ray Eames (American, 1907–78
and 1912–88). Mfr: Herman Miller
Furniture Co. Birch plywood,
27½" h x 22" w x 22½" d. Permission
to reproduce granted by the
Eames Office.

"150" armchair, 1956, Eero Saarinen
(American, born in Finland, 1910–61).
Mfr: Knoll Associates, Inc. Plastic and new
upholstery, 31⅝" h x 25¾" w x 23½" d.

DAM FACT: An Archive for Graphic Design

In 2004, the American Institute of Graphic Arts announced that it would transfer
its collection of more than 8,000 graphics, representing juried selections from its
annual competitions since 1980, to the Denver Art Museum. Winners of future
competitions will also go to the museum. This partnership has created one of the
world's largest collections of contemporary American graphic design in an
art museum.

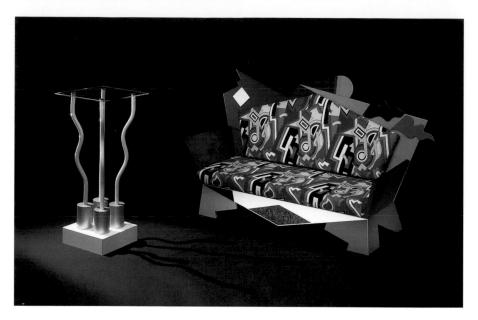

"Le Strutture Tremano" table, 1979, Ettore Sottsass (Italian, born in Austria, 1917). Mfr: Studio Alchimia. Plastic laminate, enameled metal, and glass, 46" h x 16" w x 16" d.

"Kandissi" sofa, 1979, Alessandro Mendini (Italian, born 1931). Mfr: Studio Alchimia. Lacquered wood and "Museum Market" upholstery, 48½" h x 81" l x 32" d.

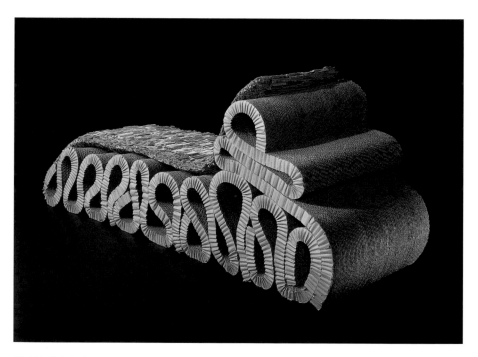

"Bubbles" chaise longue, 1979–82, Frank O. Gehry (American, born in Canada, 1930). Mfr: New City Editions. Cardboard, 33" h x 85" l x 28" d.

Beginning in the 1960s, Italian designers gained international prominence for their distinctive flair and bravura in everything from automobiles to fashion. Many of these designers looked to the fine arts as a model and elevated beauty above other design concerns. The table by Ettore Sottsass and the sofa by Alessandro Mendini are radical examples of Italian design from the late 1970s.

The major American expressionist designer of the last quarter of the twentieth century, Frank Gehry is best known as the architect of the titanium-clad Guggenheim Museum in Bilbao, Spain. Here, Gehry has taken a much humbler material—corrugated cardboard—and folded it into improbable S-curves like a giant ribbon. Part of an experimental series of cardboard furniture from 1979 to 1982, the "Bubbles" chaise was never intended for the mass market but was instead handmade and sold through galleries as expensive, limited-edition art furniture.

The 1997 chaise longue by Karim Rashid recalls modernist leather and steel chaises of the 1920s, but Rashid has made this one his own by adding curved ends, colorful upholstery, and glass shelves. Rashid represents a new generation of designers who strive to utilize the latest technologies and materials with the mass market in mind.

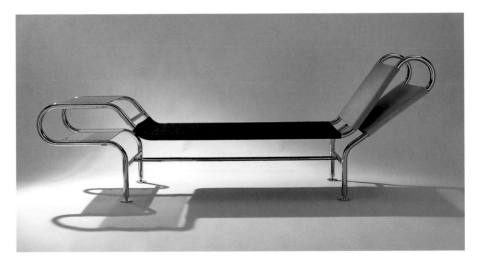

"Space" chaise longue, 1997, Karim Rashid (Canadian, born in Egypt, 1960, resides in U.S.). Mfr: IDEE, Co. Chrome-plated steel, neoprene, and glass, 32½" h x 85½" l x 22¾" d.

American Indian Art

The museum's encyclopedic collection of American Indian art is world renowned. Assembled on the dual basis of artistic merit and cultural significance, it represents nearly half of the museum's total holdings.

Tipi, 1884, attributed to Standing Bear (Minneconju Sioux, 1859–1934). Canvas and paint, 144" h x 144" diameter.

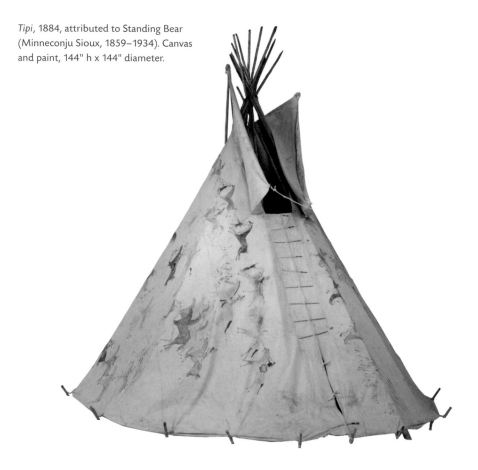

Objects from Plains tribes are the collection's greatest strength. The full-size tipi seen here is one of six that the museum owns. Tipis were originally made of buffalo hides, but by 1875, with the decline of buffalo herds and the introduction of canvas, tipi makers shifted to using this lighter weight material. The drawings show the artist's personal experiences of intertribal battles between the Sioux and their Crow and Pawnee enemies. The warriors are rendered in scrupulously accurate detail that makes it possible to recognize different tribes by their distinctive hairstyles and clothing.

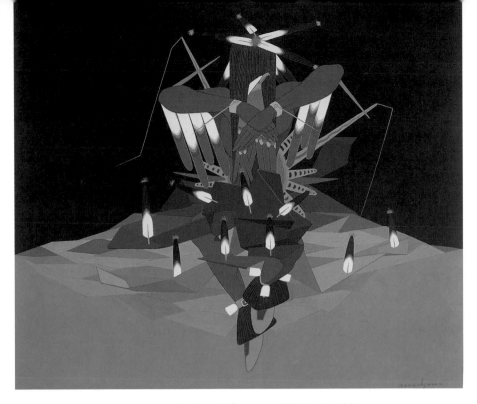

Sioux Eagle Dancer, 1954, Oscar Howe (Yanktonai Lakota, 1915–83). Casein and damar on paper, 20" h x 22½" w.

Oscar Howe challenged the definitions of Indian art with his unique and innovative style of creating figures in motion. By using lines and planes to emphasize movement, Howe both shocked and excited the Indian art world in the 1950s. Although some critics dismissed his work as derivative of European cubism, Howe maintained that his inspiration was firmly rooted in historic Sioux abstractions—such as those found in beadwork—as well as his own artistic creativity.

Beadwork is an important art form among Plains tribes. The white background, bold figures, and stepped triangles created with imported glass beads were popular design elements on Sioux and Cheyenne cradleboards from the late 1800s. The figures of horses mark this as a boy's cradleboard and express the hope that its occupant will own many horses when he grows up.

Boy's cradleboard, about 1875, unknown Cheyenne artist. Wood, beads, leather, and brass tacks, 41⅝" h.

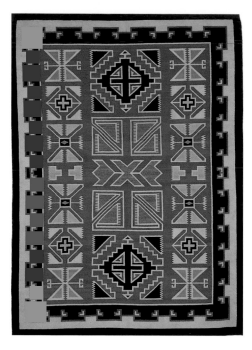

Two of the best-known American Indian artists are represented on this page. This is a rug by Daisy Taugelchee, widely considered the most talented Navajo weaver and spinner who ever lived. This tapestry, in the Two Grey Hills style, is exceptionally fine—the weaving has more than ninety wefts and twenty warps per inch and took six miles of yarn to make. When the artist finished this rug in the late 1940s, she said she'd never again attempt anything so difficult.

Rug, 1947–48, Daisy Taugelchee (Navajo, 1911–90). Wool, 69½" h x 49½"

Maria Martinez is probably the most famous American Indian potter of the twentieth century. She worked closely with her husband, Julian Martinez, who sometimes painted designs on the pottery she sculpted. This pot is one of the first they created using the matte black on polished black technique—a technique that became their signature. Their innovation shaped a new tradition for San Ildefonso pottery and influenced many artists both within and outside the Indian community.

Bowl, about 1921, Maria and Julian Martinez (San Ildefonso, 1887–1980 and 1897–1943). Clay and paint, 8¾" h. x 13½" d.

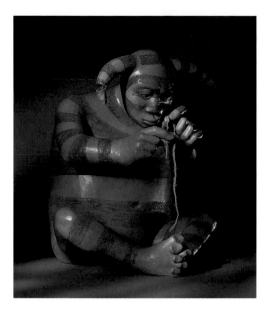

Roxanne Swentzell describes her sculpture as making the mundane significant. Her figures emanate a dignified, gentle, and fragile humanity. Here, a Tewa clown is repairing his broken horn. He crosses his eyes and toes as he focuses his attention on threading the needle. Combining a traditional process with modern convenience, Swentzell forms her figures by coiling ropes of clay in a manner similar to that used by Santa Clara potters for generations, but she uses commercial clay and an electric kiln.

The Things I Have to Do to Maintain Myself, 1994,
Roxanne Swentzell (Santa Clara, born 1962).
Clay and paint, 15½" h.

Dan Namingha comes from a family of distinguished artists. His great-great-grandmother was the famous potter Nampeyo, and many of his relatives are accomplished potters and carvers. As an abstract painter, Namingha seeks to transform images from his native experience into abstract, almost minimal forms. In *Polacca #6*, he incorporates the distinct silhouette of First Mesa, near Polacca on the Hopi reservation in Arizona, into a vivid abstraction of land and sky.

Polacca #6, 2001, Dan Namingha (Hopi, born 1950).
Acrylic on canvas, 60" h x 48" w.

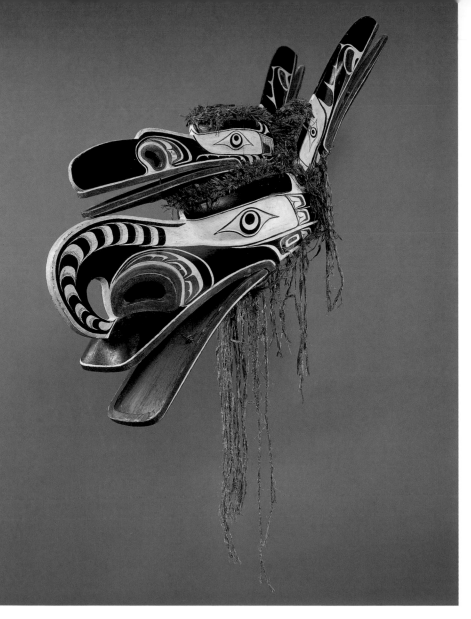

Galokwudzuwis mask, 1938, George Walkus (Kwakiutl, active 1920s–30s). Wood, paint, and cedar bark, 21" h x 51" w.

Wood carving is a highly developed art among Northwest Coast tribes, including the Kwakiutl, whose name for themselves is Kwakwaka'wakw. This mask represents a bird-monster called Galokwudzuwis, or "Crooked Beak," and is worn by a member of the Hamatsa Society. Above the "crooked beak" is the head of a crane, while two raven heads project from the back of the mask. Although the photograph shows the mask's graceful lines and bold, traditional colors of red, white, and black, it doesn't show the complex moving parts that are worked by pulling a series of strings to create sound and movement during the dance.

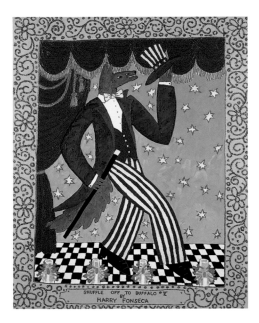

In his art, Harry Fonseca transforms Coyote, the trickster character in California Indian stories, into a contemporary Native American figure. Fonseca often sets Coyote in an urban setting, dressed in a leather jacket and high-tops. He has become as much an assertive character as a humorous one.

In this painting, Coyote takes the stage as Uncle Sam. Fonseca presents him as a stage actor and as an emblematic government figure. The glittering gold frame resembles frames used on Renaissance and baroque paintings—a reference to art history.

Shuffle Off to Buffalo #V, 1983, Harry Fonseca (Maidu, born 1946). Acrylic and mixed media on canvas, 60" h x 48" w.

Baskets richly ornamented with brightly colored feathers are a distinctive art form created by the Pomo Indians of northern California. Annie Boone, who lived at Upper Lake in Lake County in the early 1900s, was widely acknowledged as the best basket maker of her time. In this masterpiece, she richly transformed an ordinary foundation of coiled plant fiber by adding red, blue, and black feathers and pendants of clam and abalone shell.

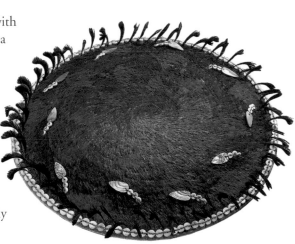

Plaque, early 1900s, Annie Boone (Pomo, 1885–1965). Plant fiber, feather, and clam and abalone shell, 10⅝" diameter.

Pre-Columbian Art

Pre-Columbian means before Columbus, and refers to the indigenous peoples and cultures of the Americas prior to European exploration and colonization—such as the Olmec people, who lived along the Gulf Coast of Mexico from around 1200 to 500 B.C. In addition to large-scale sculpture in stone, they also produced small sculpture in jade and ceramic. This hollow, hand-modeled figure is an extraordinary example of their art. Like all pre-Columbian ceramics, it is earthenware—that is, fired at a temperature under 1000 degrees Celsius. It is covered with a cream-colored clay slip that has been carefully burnished to produce a smooth, glossy finish. Like most Olmec sculptures, the figure is sexless. The limbs are smooth, rounded forms that in no way reflect the anatomical reality of bones and muscle. The delicately modeled oval face has slanted, slitlike eyes and the characteristically Olmec downturned mouth.

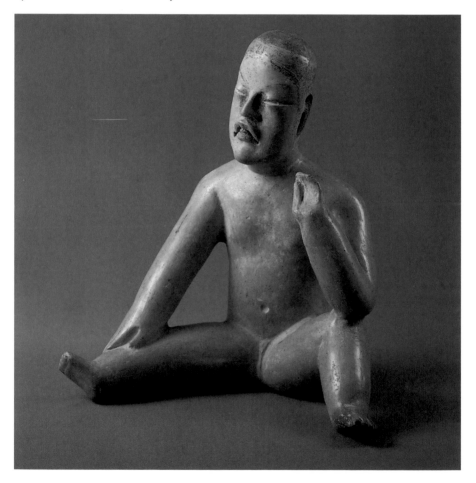

Seated figure, Olmec, about 1000–500 B.C., Zumpango del Río, Guerrero, Mexico. Earthenware with slip, pigments, 14" h.

This photo of a Maya vase shows only a portion of a scene that covers the entire vessel. Scholars think that the scene depicts a marriage negotiation between a ruler (the large figure at right) and another man. You can't see the two women— presumably the ruler's wife and daughter—who eavesdrop behind a curtain. But you can see several indications of the importance of chocolate to the Maya. Next to the ruler is a cup with a peaked lid used for drinking chocolate, and below him are two large bags filled with cacao beans (used to make chocolate), which served as currency as well as cuisine. The graphics around the rim are a hieroglyphic text that tells us the name of the vase's first owner and the vase's function as a drinking vessel for chocolate.

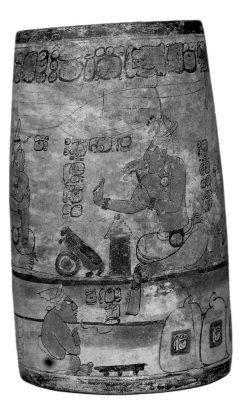

Vase with palace scene, Maya, A.D. 600–900, Mexico or Guatemala. Earthenware with colored slips, 11¼" h.

The Denver Art Museum's collection of Costa Rican art is encyclopedic, with extensive, aesthetically outstanding holdings of stone sculpture, jade, ceramics, and gold ornaments like the pendant seen here. This pendant has been identified as a catfish because of the barbels beside its mouth. However, the presence of serpents with serrated bodies that emerge from the mouth suggest a being with special powers.

Catfish pendant, about A.D. 700–1550, Diquís, Costa Rica. Gold, 4¼" h.

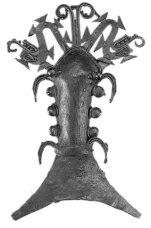

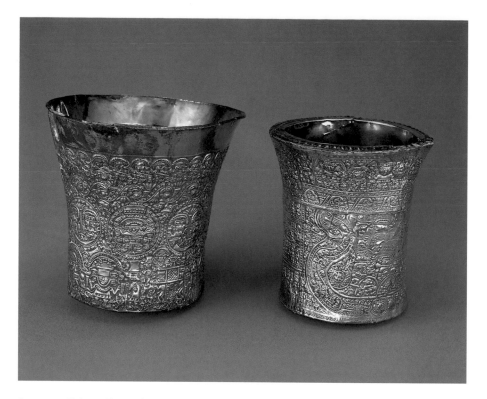

Large cups, Sicán or Chimú, about A.D. 800–1550, North coast, Peru. Silver. Left: 7" h. Right: 6" h.

In terms of imagery, the two silver cups seen here are the most complex artworks ever recovered from ancient Peru's north coast. Both are formed of sheet silver with repoussé decoration created by pushing out from the inside surface of the metal. The cup on the left features roundels with scenes involving spondylus (spiny oyster) shell, an orange-colored shell sacred to many ancient Andean peoples. Below them may be a procession with litters, a cupbearer, and a figure bearing crops. Imagery on the cup at right is even more elaborate: architectural compounds, gardens, boats, deer hunters, and supernatural beings are all included in what may be episodes of a mythological story. The giant serpent filled with fish may represent a river.

One of the most impressive known examples of Colombian ceramic art is this seated male figure from the Popayán region of west-central Colombia. The figure's commanding pose, elaborate head-dress and shield, and gold necklace suggest an individual of wealth and power, probably a chief. His swollen calves reflect the use of ligatures (bands) tied below the knee and at the ankle, a practice in use by Amazonian peoples today. The reptile clinging to the figure's back—either a symbolic costume element or a spiritual companion—is similar to animal forms found behind the large stone figures at the archaeological site of San Agustín in western Colombia.

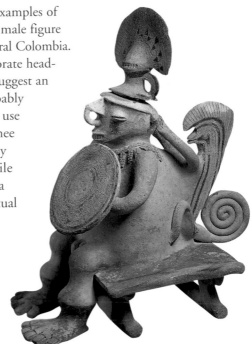

Figure seated on a bench, before A.D. 1500, Popayán, Cauca River valley, Colombia. Earthenware with slip, 15" h.

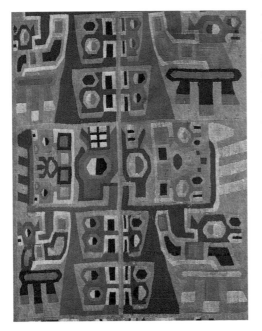

Wari tapestry tunics were extremely labor-intensive. The tunics were generally woven with cotton warps and very fine, densely packed alpaca wefts. Alpaca fiber takes dye readily; vibrant reds, pinks, and yellows were especially favored, as seen in the detail photograph. To make a tunic, several weavers worked side by side, probably in a state-sponsored workshop, to produce a wide panel of cloth. Two panels were then stitched together, with slits for the head and arms.

Tunic (detail), Wari, about A.D. 650–800, Peru. Interlocked tapestry with cotton warps and camelid fiber wefts, 81½" h x 40½" w.

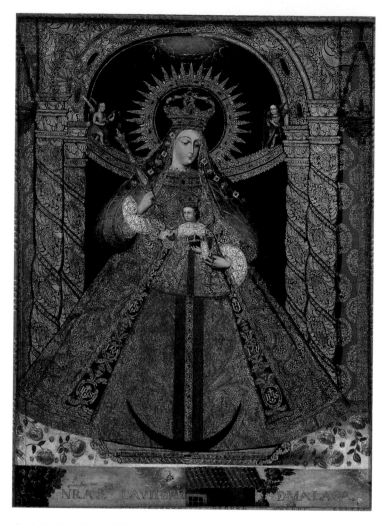

Our Lady of the Victory of Málaga, about 1740, Luis Niño (Bolivian, about 1720–60), Potosí region, Bolivia. Oil on canvas, 59" h x 44" w.

Although Lima became the political capital of colonial Peru, Cuzco remained its artistic capital, as it had been in Inca times. The extraordinary use of gold stamping to create the pattern on the cloth and the columns in this painting is exclusive to Cuzco and the surrounding area, including Bolivia. While much of the imagery derives from Spanish Catholic traditions, there are distinctively Peruvian touches, such as the red and blue wings of the angelic musicians (red and blue feathers were sacred to the Inca and were symbols of nobility). The landscape fragments at the bottom are the surviving upper halves of two sequential scenes depicting a miracle performed by the Virgin of Málaga.

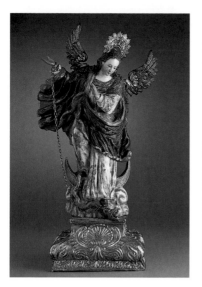

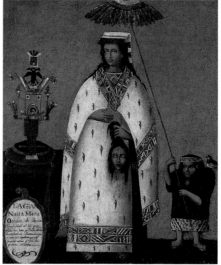

Virgin of Quito, 1725–50, Quito, Ecuador. Carved wood, paint, and silver, 18" h.

Inca Princess, about 1800, Cuzco, Peru. Oil on canvas, mounted on board, 18" h x 15" w.

In the 1700s, Quito, the capital of Ecuador, was internationally known for its finely made wooden sculpture. This beautiful example is characteristic of the delicate carving and elaborate painting produced in the studio of Bernardo Legarda. Although the figure's downward gaze is serene, the jutting mantle that encircles the figure and the upturned wings that echo the crescent shape of the base give a sense of movement to the sculpture. Statues of the Virgin of Quito were typically adorned with a hammered silver halo and wings.

This painting is a posthumous portrait of an ancestor, undoubtedly commissioned by her descendants in the late colonial period to assert their claims to Inca nobility. The inscription claims that she was the first Christian Inca woman in the Andes and that when a man tried to violate her vow of chastity, she fought and beheaded him. In doing so, she recreated a feat credited to Mama Occllo, the first queen of the Inca dynasty, who conquered Cuzco by decapitating an enemy. Her deed also echoes that of the Old Testament's Judith, who saved the Jewish nation by beheading the Assyrian general Holofernes.

DAM FACT: The Mayer Center

· ·

A generous gift from longtime museum supporters Frederick and Jan Mayer underwrites four staff positions in the New World Department and funds the Frederick and Jan Mayer Center for Pre-Columbian and Spanish Colonial Art. The Mayer Center sponsors scholarly activities including annual symposia, fellowships, study trips, and publications. Mayer Center publications already in print include *Painting a New World: Mexican Art and Life, 1521–1821* and *Tiwanaku: Ancestors of the Inca.*

When Spanish settlers arrived in the southwestern United States at the end of the 1500s, they brought with them paintings and sculptures of Catholic saints for their churches and homes. Soon afterward a local tradition of making such images developed. Spanish devotional artists *(santeros)* learned from local Pueblo Indians how to make paints from native plants and minerals. They combined these homemade paints with oil paints imported from Mexico to make images of religious figures known as *bultos* (sculptures) and *retablos* (paintings on wood panels). Both are still made in the area today.

No image is as distinctively Mexican as the Virgin of Guadalupe, with her characteristic spiky aura and blue robe with gold stars. Here the Virgin is surrounded by prophets, saints, angels, and seven miniature scenes of her miracles, all identified by inscriptions. At the bottom, Pope Benedict XIV and an Aztec princess (symbolizing Mexico) flank a landscape showing the Virgin's church north of Mexico City. Painted on copper in Mexico City in 1779 by Sebastián Salcedo, this image was brought to Santa Fe, New Mexico, around 1800 to hang in the new adobe church of Our Lady of Guadalupe.

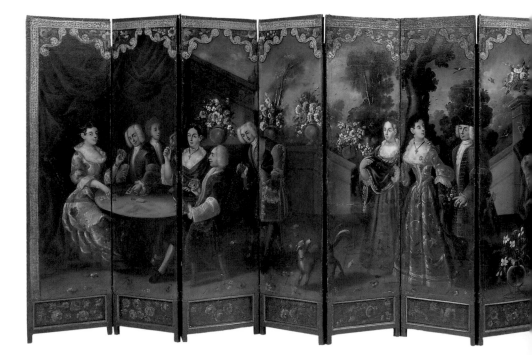

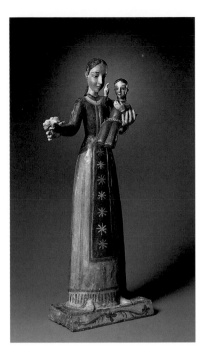

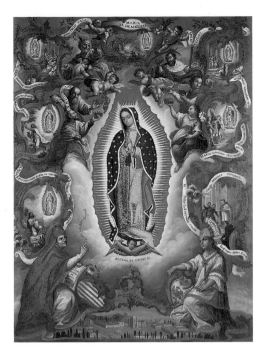

Bulto of Our Lady of Mount Carmel, early 1800s, Rafael Aragón (New Mexican, about 1790–1862), Santa Fe or Córdova, New Mexico. Wood, gesso, paint, 29" h.

Virgin of Guadalupe, 1779, Sebastián Salcedo (Mexican, active 1779–83). Oil on copper, 25" h x 19" w.

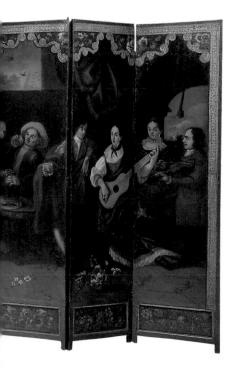

Inspired by Asian examples, colonial Mexicans used folding screens to divide spaces, block drafts, and create privacy in their homes. This screen provides a glimpse into upper-class life. Clusters of people are shown enjoying a garden party on the terrace of a country home. They play cards, gamble, smoke, flirt, drink, or make music. There are only about a dozen screens in existence with scenes like this; all were made in Mexico City in the 1700s and most are in private collections. The Denver Art Museum's screen is one of the earliest known and is the only such screen in a U.S. museum.

Garden party on the terrace of a country home, about 1730, artist unknown, Mexico. Ten-panel folding screen, oil and gold leaf on canvas, 87" h x 219" l.

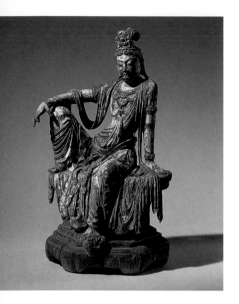

The form of Buddhism that became popular in China centered on the worship of bodhisattvas, beings who postpone their own escape from worldly existence in order to help others attain enlightenment. One bodhisattva in particular attracted the devotion of Chinese Buddhists—Guanyin, the Bodhisattva of Infinite Compassion, whose name means "the one who always hears [prayers]." Unlike Buddhas, who wear simple robes and have short curls of hair, bodhisattvas are depicted with elaborate clothing, jewelry, and hairstyles.

Guanyin, 900s, China. Polychromed wood, 17" h.

One of the most influential painters of twentieth-century China, Zhang Daqian is said to have transformed traditional Chinese painting into a contemporary form. He combined the talent and skill of the masters with the bold, innovative brushwork of a modern artist. This painting is inscribed, "Dedicated to Madam Shu Qing [Mrs. Wong Pao Hsie], a connoisseur, for her amusement. Dated the spring of 1963." After leaving China in 1949 in the wake of the Chinese Civil War, Zhang Daqian traveled widely and lived in Brazil, California, and Taiwan.

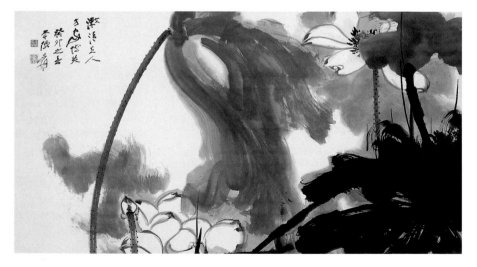

Lotus, 1963, Zhang Daqian (Chinese, 1899–1983). Ink and color on paper, 28" h x 52" w.

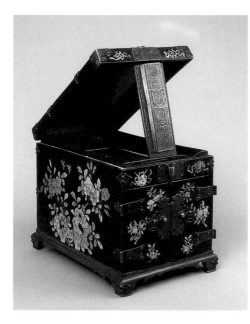

This chest for grooming accessories and hair ornaments is called *chagae pitchop* in Korean, which means "comb chest." The lid has a brass prop that is engraved with the Buddhist incantation "Hail to the jewel in the lotus!" in Sanskrit characters. Widely used in all sects of Korean Buddhism, the phrase was recited as a prayer for good fortune in veneration of Kwanum, the Korean name for the Bodhisattva of Infinite Compassion.

Comb chest, Choson period, 1800s, Korea. Lacquer, mother-of-pearl, and brass, 9⅞" h.

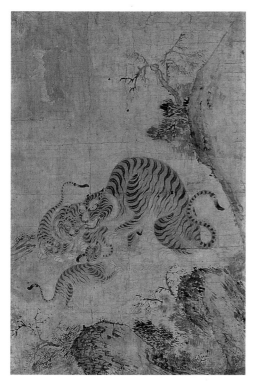

Now extinct, the Korean tiger was admired for its strength and independent spirit. In earlier centuries, paintings of tigers were displayed in Korean homes to celebrate the New Year. These images were intended to ward off evil spirits and served as guardians for the family household during the year ahead.

Family of Tigers, Choson period, 1600s, Korea. Ink and color on paper, 23" h x 14⅝" w.

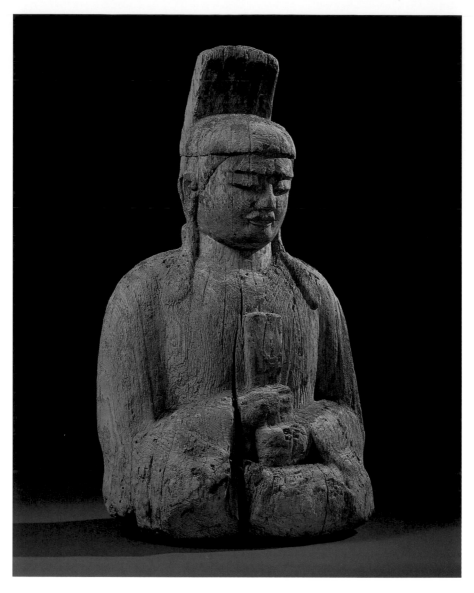

Shinto deity, Heian period, 900s, Japan. Zelkova wood, 33½" h.

One of the oldest and largest Shinto sculptures outside of Japan, this male deity is carved from a single tree trunk and preserves the tree's original girth without attachments or joinery. The figure is seated in a formal position and dressed in court attire with a hat with long lappets. He holds a flat scepter, a symbol of high status. Shinto art is sometimes called an "invisible art" because its images and sacred objects were intentionally concealed in shrines, where they were worshiped unseen by devotees.

This fragmentary representation of a winged figure once formed part of a wall relief in the Northwest Palace of the Assyrian king Assurnasirpal II (reigned 883–859 B.C.) at Calah (Nimrud), situated south of Mosul in Iraq. Originally painted with bright colors, the entire relief panel probably depicted a second winged figure to the left of a central tree to create a symmetrical composition typical of Mesopotamian art.

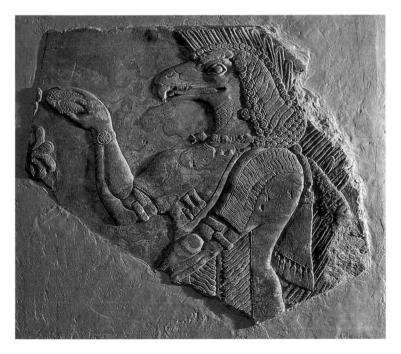

Winged figure, 800s B.C., Calah, Iraq. Limestone, 19½" h.

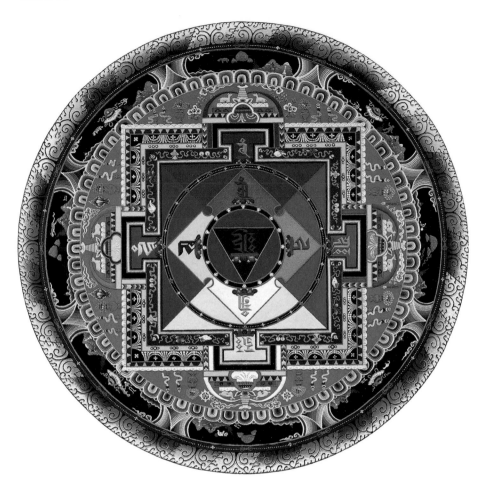

Hayagriva mandala, 1996, monk-artists of Seraje Monastic University, India: Geshe Thubten Sonam (Tibetan, born in India, 1965), Sonam Woser (Tibetan, born 1964), and Lobsang Lungrig (Tibetan, born 1974). Sand mixed with mineral pigments, 57" diameter.

One of the most exquisite Tibetan art forms, sand mandalas are intricate "paintings" that symbolize the universe and its powers. A mandala typically represents a particular deity's palace and grounds and illuminates a guiding spiritual principle. This mandala was made at the Denver Art Museum by three Tibetan monks over a two-week period in September 1996. Normally, sand mandalas are ritually dismantled after completion, but the museum was given permission to preserve and display this mandala. It is one of very few Tibetan sand mandalas ever preserved for permanent viewing.

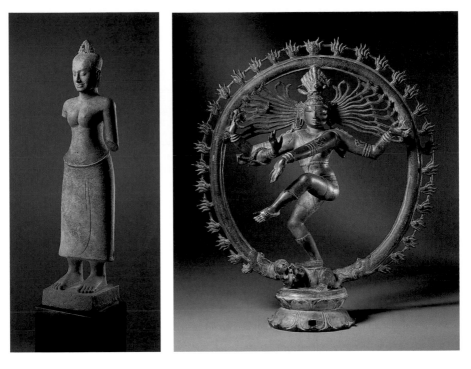

Goddess of Transcendent Wisdom,
Prajnaparamita, Angkor period,
late 1100s–early 1200s, Cambodia.
Sandstone, 59" h.

Shiva, King of Dancers (Shiva Nataraja), Chola dynasty, 1100s,
Tamil Nadu, India. Bronze, 36⅞" h.

Prajnaparamita is the Buddhist Goddess of Transcendent Wisdom. This standing figure is one of a few surviving Prajnaparamita images that purport to be a likeness of the mother of King Jayavarman VII (reigned 1181–1218) or of his first wife, Queen Jayarajadevi. The gentle smile and lowered eyes are features associated with sculptures from the Bayon temple built by Jayavarman VII, the last great ruler in the Angkor royal line.

As Nataraja, the king of dancers, Shiva dances the universe into and out of existence. The sound of his drum heralds its creation; his burning flame signals its final conflagration. He raises one hand to allay fear and points another toward his upraised foot, a symbol of release. In his dance, Shiva tramples on the demon of forgetfulness, shown in the form of an infant. The cycle of time—past, present, future—runs through the circle of flame within which Shiva dances.

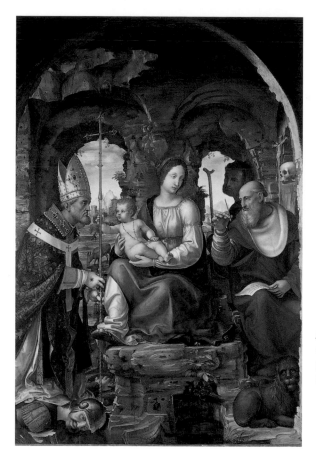

Madonna and Child with Saints,
about 1511, Bernardo Zenale
(Italian, about 1436–1526).
Oil on panel, 71" h x 48½" w.

Originally the central panel of a large altarpiece, this painting on wood has been attributed to many artists over the years—including Leonardo da Vinci—but is now believed to be the work of the northern Italian painter Bernardo Zenale. In the center, the Madonna holds the infant Jesus. She is flanked by St. Jerome (on the right, accompanied by his lion) and St. Ambrose (on the left, kneeling atop a fallen warrior). Joseph stands behinds Jerome. The treatment of the figures and drapery owes much to Leonardo, but instead of his subdued palette, Zenale has opted for more vivid colors.

During the 1500s, people associated the seasons with stages of human life. Spring stood for youth, and winter conjured up images of old age. *Summer* shows a man in his prime—a man, that is, composed of the ripest produce the season has to offer. In this painting, the different qualities of each fruit and vegetable add character to the face. A row of peas makes for straight, even teeth, and a cucumber makes for a bumpy-skinned nose.

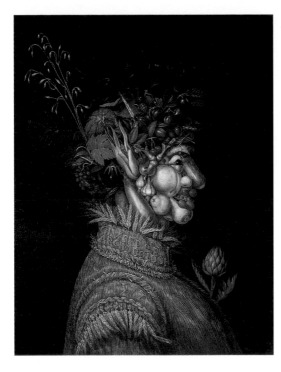

Summer, 1572, Giuseppe Arcimboldo (Italian, 1527–93). Oil on canvas, 36" h x 27¾" w.

Four Saints (detail), about 1480, Carlo Crivelli (Italian, 1430–98). Oil on panel, 25½" h x 24¼" w.

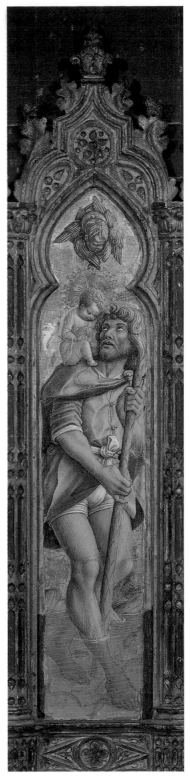

This panel of St. Christopher carrying the Christ Child across a river is thought to be one of a set of twelve painted by Carlo Crivelli for the cathedral in Camerino, Italy. Four are now owned by the Denver Art Museum, and the central panel is at a museum in Milan, the Pinacoteca di Brera. Crivelli lived in a part of Italy isolated from many of the stylistic and technical innovations of the Renaissance, and, as a result, many elements of his artwork are aligned with earlier traditions. Instead of adopting oil by itself as a medium, he remained faithful to the traditional tempera on panel technique and continued to rely on gesso and flat gold backgrounds.

At the time of his death in 1905, William-Adolphe Bouguereau was one of the most beloved and most hated artists in France. He never strayed from his conservative style, despite the artistic revolution swirling around him. Some people were awed by his skill; others found him sappy and old-fashioned. He steadfastly maintained that art should be beautiful: "Why produce what is ugly?" He wanted his art to be timeless, too, so instead of the latest fashions, the girls in this painting wear peasant-type clothing that could belong to several different centuries and sit in an imaginary countryside emptied of signs of modern life. In reality, the models probably posed in his studio.

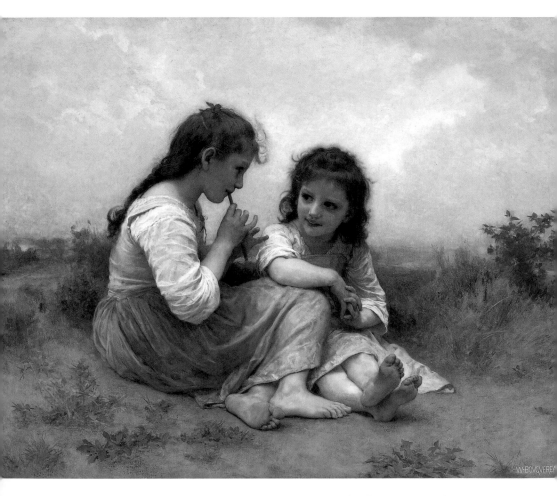

Childhood Idyll, 1900, William-Adolphe Bouguereau (French, 1825–1905). Oil on canvas, 39⅛" h x 50⅜" w.

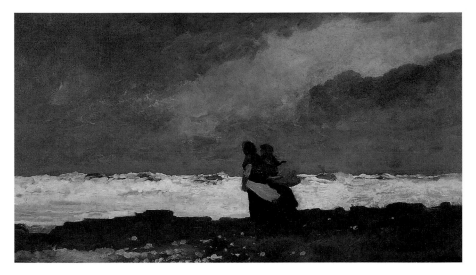

Two Figures by the Sea, 1882, Winslow Homer (American, 1836–1910). Oil on canvas, 19¼" h x 34⅜" w.

Winslow Homer made this painting during an extended stay in a little village facing England's North Sea. He was fascinated by the big, strong women who worked hard baiting hooks, repairing nets, hauling and cleaning fish, hawking them at market, and preparing the boats for the next day—in addition to doing household chores and raising the children. These women may be waiting for their husbands' boats to return. The sand is dark, as if soaked with rain, and the sea is almost entirely white foam.

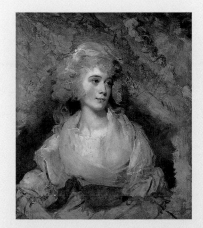

DAM FACT: British Art

Though natives of the American West, Bill and Bernadette Berger assembled an impressive collection of British art that spans six hundred years, from the 1300s to 1900s. Under the auspices of the Berger Collection Educational Trust, which encourages the use of the collection as a public educational resource, changing selections from the collection are on display on the museum's sixth floor.

Portrait of a Lady (said to be Lady Cecil Hamilton, Marchioness of Abercorn), about 1793, Sir Thomas Lawrence (British, 1769–1830). Oil on paper laid on canvas, 29⅞" h x 25⅛" w.

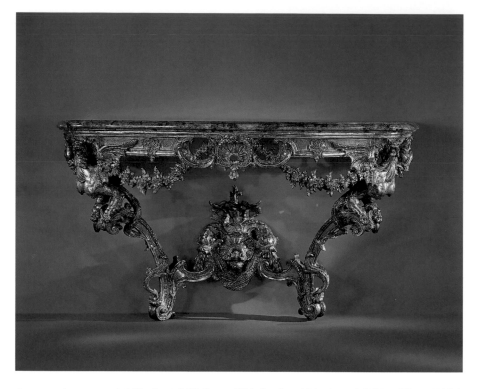

Baroque and rococo console table, about 1730, France. Gilded and marbleized wood, 37" h x 68" w x 28¾" d.

This ornate console table is part of a group of objects that were acquired over a number of years for the sixth-floor decorative arts gallery to give visitors a dramatic demonstration of eighteenth-century French taste. The table is a tour de force of carving that features popular baroque elements such as dolphins (at the center base) and winged dragons (on the side supports). The more delicate floral garland swags are typical of the slightly later rococo style.

DAM FACT: Design Exhibitions

The Denver Art Museum has made its mark in the art world with a series of contemporary design shows. The first such exhibition, *Masterworks: Italian Design 1960–1994*, premiered at the Denver Art Museum in 1994 and subsequently toured in North America under the auspices of the American Federation of Arts. *USDesign 1975–2000* debuted at the Denver Art Museum in 2002 before embarking on a national tour.

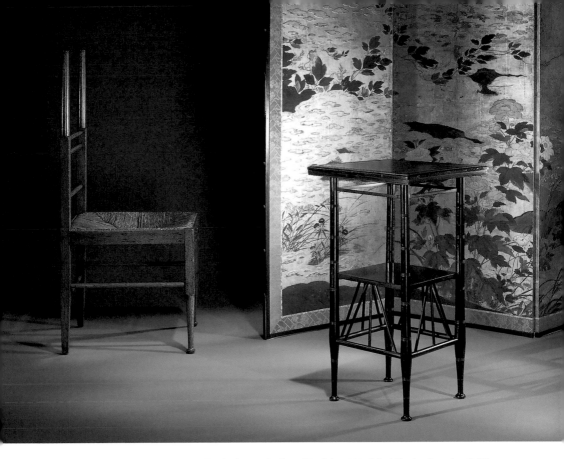

"Greek" side chair, about 1885, school of E. W. Godwin (English, 1833–86). Mfr: Attributed to William Watt. Oak and rush, 41¼" h x 16¼" w x 18¼" d.

"Japonesque" table, about 1880, school of E. W. Godwin (English, 1833–86). Mfr: Collinson & Lock. Ebonized wood, 28" h x 16" w x 16" d.

Chrysanthemums and Autumn Grasses, Edo period (1615–1868), Japan. Folding screen, ink, color, and gold on paper, 69¾" h x 141" l.

The table and chair seen here are both in the style of the English furniture designer E. W. Godwin. Designed in the 1880s, these objects were revolutionary for their time and are now seen as a precursor to much of twentieth-century design. Godwin set aside the prevailing Victorian love of exuberant naturalistic ornament in favor of a simplicity and lightness of form that was influenced by the rapid industrialization of Western society and by Japanese design. Still, the actual designs are not as austere as they first appear. The table has a complex arrangement of diagonal braces, and its legs have incised turnings and elegant tapered feet. And while the chair has been reduced to the sparest wood frame with a rush seat, the detailing of the frame is quite complex in its composition of square, circular, and tapered forms.

Textile Art

Religious and secular imagery decorates this chasuble, an ecclesiastical vestment worn by a priest celebrating the Mass. The back of the vestment is shown here. The center orphrey band is embroidered with saints associated with the Carmelite order—St. Albert of Jerusalem (top) and St. Teresa of Avila (bottom)—with the Virgin and Child and St. Michael the Archangel overcoming Satan in between. To either side of the orphrey, as well as on the front of the vestment, naturalistic flowers are gathered into bouquets and tied with bowknots.

Chasuble, 1676, central Europe. Silk embroidered with silk and metal thread, 44¼" h x 29¾" w (maximum dimensions).

The Empress Dowager Cixi (1835–1908), the power behind China's Manchu throne, is known to have disliked the imperial yellow color, judging it unflattering to her complexion. She is thought to have personally designed this robe's wide, dark borders to reduce the reflection of the yellow silk on her face. Made of light-weight gauze, the robe was worn during the summer and is decorated with a pattern of *wanshou* medallions that wish the wearer "ten thousand ten thousand longevities," or a very, very long life. This robe is one of more than six hundred garments and accessories collected in China in the early 1900s by Charlotte Hill Grant.

Woman's informal robe, Qing dynasty, early 1900s, China. Silk gauze embroidered with silk tent stitch and couched metal thread, 53" h x 52" w.

Crazy quilt, late 1800s, Lydia Hooley King (American Amish, 1814–1904), Mifflin or Lancaster County, Pennsylvania. Wool with cotton embroidery, 72" h x 70" w.

From their introduction in the 1870s to their decline in popularity in the 1920s, crazy quilts were all the rage in the United States. Non-Amish quilt makers frequently assembled irregularly shaped fragments of silk, velvet, and luxury fabrics—even personal mementos—into showpieces that were further embellished with embroidery, tassels, and trimmings. Conservative by comparison, Amish crazy quilts were made from solid-colored materials and without excessive ornamentation. The decorative stitches and scalloped border place this example outside the Amish norm.

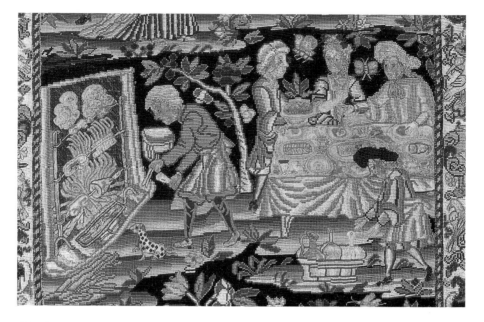

"Courtly Festivities" wall panel (detail), about 1700, the Netherlands or northern France. Linen with silk and wool embroidery in cross, gros, and petit point stitches, 111½" h x 48" w.

An embroidered panel from France or the Netherlands presents a rare glimpse of the leisurely life of nobles in the late 1600s. Four scenes depict in remarkable detail a host greeting his guests in front of his stately home, outdoor musical entertainment, after-dinner dancing in a garden, and the lavish feast seen here. Guests are seated at a table while one servant (attentively watched by a spotted dog) roasts meat on a spit, and another selects wines and beverages from a basin that is being kept cool in a pond.

DAM FACT: Protecting the Art

Objects like textiles, photographs, and works on paper are displayed only for short periods of time so they don't fade. When off view, they are stored in specially designed, darkened storage areas where temperature and humidity can be precisely controlled. Labels and other informational material in the galleries tell more about how the museum conserves and protects its objects.

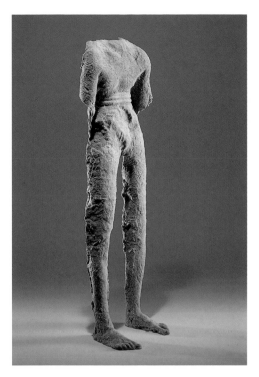

Originally known for her woven art works, the Polish artist Magdalena Abakanowicz became intrigued in the 1970s with sculptural forms inspired by the human figure. Her figures, shown singly and in groups, were created from materials ranging from fabric to bronze and have won international recognition. Made of burlap and sand, *Standing Figure* appears about to metamorphose from or dissolve into its unlikely and seemingly unstable materials.

Standing Figure, 1981, Magdalena Abakanowicz (Polish, born 1930). Resin and sand on burlap, 62" h.

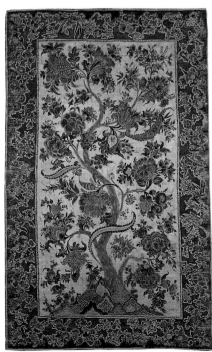

Twisting and turning as it rises from the rocky ground, this sinuous tree of life bursts into flower with large, showy blossoms. Made in India through a labor-intensive process of repeated dyeings, such hangings were widely exported. The details of the design and coloration were adapted for specific markets. This particular type of hanging was highly prized by the Toraja people of Sulawesi, Indonesia, who believed the cloth had special powers and used it for ceremonial purposes.

Palampore, late 1600s–early 1700s, Coromandel Coast, India. Resist and mordant dyed cotton, 74" h x 46" w.

In & Around DAM

The Denver Art Museum is not just about the art—it's about visitors interacting with art. In addition to tours, classes, and other scheduled programs, there are plenty of places to go and things to do that enhance the art experience. Ask at the Welcome Center for more information about anything on these pages.

The museum has made a special commitment to families. Seymour, the museum's cheerful monkey mascot, is the key to finding games and hands-on activities for kids and their adult companions.

The museum's popular Family Backpacks have inspired similar programs in museums across the United States. Each backpack is crammed full of games and activities that send families on a journey through the galleries. Here, a family plays a matching game in the Hispanic Southwest gallery.

The Just for Fun Family Center offers a place for kids and parents to take a break and play. Families can design a chalkboard chair, play a Japanese shell game, dress up like an Egyptian animal, or build elaborate architectural structures like the kids here are doing. All of the games and activities link to the museum's collections.

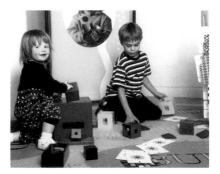

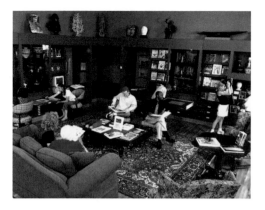

The museum is nationally recognized for its innovative approach to installing its collections. The Discovery Library on the North Building's sixth floor lets visitors enjoy the art from the comfort of a plush sofa or up close as they rummage through drawers. Books, computers, and a costume closet for kids add to the relaxed ambience.

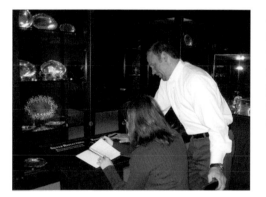

Adults are invited to explore the collections in unexpectedly personal ways through sketching stations, notebooks, and video booths that prompt visitors to "tell us your story." Here, visitors respond to a display of Spanish colonial silver.

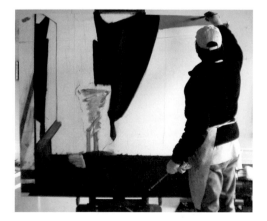

One of the hallmarks of the museum's interpretive approach is connecting visitors with artists. A multimedia area in the western American art galleries takes visitors through the making of Daniel Sprick's hyper-realistic painting, *Release Your Plans* (here shown in progress). Other galleries use video interviews, illustrated labels, and objects from the artist's studio to present the artist's perspective.

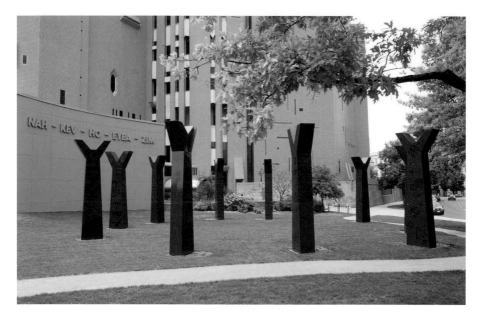

Wheel, 2005, Hock E Aye Vi Edgar Heap of Birds (Cheyenne/Arapaho, born 1954). Porcelain on steel, 12' h (each standing form).

A walk around the museum complex provides intriguing views of each of the buildings and the surrounding neighborhood as well as encounters with public sculpture. Situated on the south side of Thirteenth Avenue under the "prow" of the Frederic C. Hamilton Building is *Big Sweep*, by Coosje van Bruggen and Claes Oldenburg. On the opposite (south) side of the building is *Scottish Angus Cow and Calf*, by the Colorado artist Dan Ostermiller, and across from the Hamilton Building entrance (near the parking garage) is an untitled sculpture by Beverly Pepper. Acoma Plaza, between the North Building and the Denver Public Library, is home to the two sculptures pictured here.

Inspired by Native American architectural forms and the Big Horn medicine wheel in Wyoming, *Wheel* is composed of ten tree forms arranged in a circular shape that is fifty feet in diameter. The trees are aligned to the summer solstice— on June 21, the sun rises in an opening to the east between the first and last trees. Artist Hock E Aye Vi Edgar Heap of Birds covered the forked red tree forms with text and imagery related to the history of Indian people in the United States and indigenous peoples elsewhere. Each tree addresses a specific theme, from conflict over resources to global cooperation among indigenous peoples. In addition to the tree forms, the sculpture incorporates a curved exterior wall of the museum, where the Cheyenne words *nah-kev-ho-eyea-zim* appear in raised letters. The phrase means "We are always returning back home again."

Lao Tzu was not enlarged from a smaller model nor was it built in a foundry. Rather, the artist Mark di Suvero gathered the materials necessary to realize his vision and, using a construction crane and platform, begin to assemble sixteen tons of steel I-beams and sheet-metal arcs. For four years, he rearranged these components in his Long Island City studio. The Denver Art Museum bought the sculpture in 1995, and it was trucked in pieces to Colorado so that di Suvero could make the final decision about exactly where it should be placed. The title *Lao Tzu* pays homage to the Chinese philosopher who founded Taoism in the sixth century B.C. and suggests, like the Taoist concept of *yin-yang*, a union of opposites: it is both grounded and soaring, heavy and weightless.

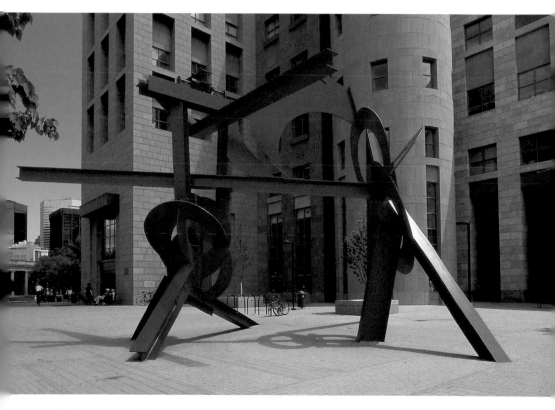

Lao Tzu, 1991, Mark di Suvero (American, born 1933). Painted steel, 29' h x 16' w x 36' d.

P4: Native Arts Department acquisition funds. P7: Funds from 1983 Collectors' Choice, Dr. Charles & Linda Hamlin, Sheila Bisenius, Phyllis & Aron B. Katz, Jan & Frederick Mayer, Caroline & Rex L. Morgan, Gulf Oil Foundation, Marsha & Marvin Naiman, Joel S. Rosenblum Fund, and anonymous donors. P8: Purchased in memory of Bob Magness with funds from Collectors' Choice 1999, Sharon Magness, the Flowe Foundation, Mr. & Mrs. William D. Hewit, Mr. & Mrs. Carl M. Williams, the T. Edward and Tullah Hanley Collection by exchange, Denver Broncos, Mr. & Mrs. Cortlandt S. Dietler, Mr. & Mrs. Charles P. Gallagher, Mr. & Mrs. Frederic C. Hamilton, Mr. & Mrs. Frederick R. Mayer, Mr. & Mrs. Thomas A. Petrie, Timet Corporation, and the citizens who support the Scientific and Cultural Facilities District. P9: William Sr. and Dorothy Harmsen Collection. P10: Gift of the Magness family in memory of Betsy Magness. P11: Funds from the William D. Hewit Charitable Annuity Trust. P12 (top): William Sr. and Dorothy Harmsen Collection. P12: (bottom) Funds from Contemporary Realism Group. P13: Funds from Contemporary Realism Group. P14: Purchased in honor of Mr.& Mrs. Frederic C. Hamilton with funds from Collectors' Choice 1997, the Anschutz Foundation, Jan & Frederick Mayer, UMB Bank, U.S. Trust, and other donors by exchange. P15 (top left): Anonymous gift. P15 (top right): Anonymous bequest. P15 (bottom): Funds from Helen Dill bequest. P16: Herbert Bayer Collection and Archive: Gift of BP Corporation. P17 (top): Gift of Mr. & Mrs. Walter Maitland. P17 (bottom): Funds from Peter Norton Family Foundation, Cathey & Richard Finlon, and Modern and Contemporary Department acquisition funds. P18: Funds from NBT Foundation. P19 (top): Charles Francis Hendrie Memorial Collection. P19 (bottom): Gift of Nancy M. & Donald F. Todd in honor of Dianne Perry Vanderlip. P20 (top): Charles Francis Hendrie Memorial Collection by exchange. P20 (bottom): Funds from Colorado Contemporary Collectors: Suzanne Farver, Linda & Ken Heller, Jan & Frederick Mayer, Beverly & Bernard Rosen, and Annalee & Wagner Schorr; 1985 and 1986 Alliance for Contemporary Art Auctions by exchange; and anonymous donors. P21: Acquired by the Denver Art Museum in memory of Lewis W. Story. P22 (top): Funds from 1996 Collectors' Choice and partial gift of Valerie Franklin. P22 (bottom): Gift of Fred H. Riebling. P23: Joan Evans Anderman Memorial Fund. P24: Gift of Joan & George Anderman. P25 (left): Gift of Joan & George Anderman. P25 (right): Purchased with funds donated in memory of George G. Anderman. P26 (top): Promised gift of Daniel Wolf. P26 (bottom): Gift of Mr. & Mrs. Theodore R. Gamble Jr. P27 (top): Purchase from the Edith M. Daly Fund. P27 (bottom): Funds from the Florence R. and Ralph L. Burgess Trust and the Ice House Benefit Fund. P28 (top): Funds from Mr. & Mrs. Erving Wolf (table); Funds from Estelle R. Wolf (sofa). P28 (bottom): Gift of J. Landis and Sharon S. Martin. P29: Funds from Design International. P30: Native Arts Department acquisition funds. P31 (top): Santa Fe Railroad Purchase Award, Fourth Annual Exhibition of Contemporary American Indian Painting. P31 (bottom): Native Arts Department acquisition funds. P32 (top): Native Arts Department acquisition funds. P32 (bottom): Gift of Frederic H. Douglas. P33 (top): Funds from Polly & Mark Addison. P33 (bottom): Gift of the Douglas Society. P34: Native Arts Department acquisition funds. P35 (top): Native Arts Department acquisition funds. P35 (bottom): Gift of R. B. Bernard. P36: Funds from various donors. P37 (top): Funds from various donors, Volunteer Endowment Fund, and New World Department acquisition funds. P37 (bottom): Gift of Jan & Frederick R. Mayer. P38: Gift of Jan & Frederick R. Mayer (left cup); New World Department acquisition funds (right cup). P39 (top): Gift of Mr. & Mrs. Edward M. Strauss in memory of Alan Lapiner. P39 (bottom): Neusteter Textile Collection: Funds from 1986 Collectors' Choice. P40: Gift of John C. Freyer for the Frank Barrows Freyer Collection. P41 (left): Gift of Mr. & Mrs. John Pogzeba. P41 (right): Gift of Dr. Belinda Straight. P42: Lent by Frederick & Jan Mayer. P43 (left): Funds from Walt Disney Imagineering. P43 (right): Gift of Mr. & Mrs. George G. Anderman and an anonymous donor. P44 (top): Walter C. Mead Collection by exchange. P44 (bottom): Gift of the children of Mr. & Mrs. Wong Pao Hsie. P45 (top): Museum purchase. P45 (bottom): Anonymous gift. P46: Funds from Edith Trimble Zinn bequest in memory of her husband, Comdr. Ralph Theodore Zinn. P47 (top): Gift of Adelle Lutz and David Byrne. Photo by Erik Kvalsik. P47 (bottom): Charles Bayly Jr. Fund and general acquisition funds. P48: Museum purchase with funds from the Asian Art Association, Mr. & Mrs. Yale H. Lewis, NBT Foundation, Fay Shwayder, and the Asian Art Department Acquisition Fund. P49 (left): Purchased in honor of Emma C. Bunker with funds from Collectors' Choice 2000, the Sam F. and Freda Davis Charitable Trust, and various donors. P49 (right): Funds from Dora Porter Mason bequest. P50: Gift of the Samuel H. Kress Foundation. P51 (left): Funds from Helen Dill bequest. P51 (right): The Simon Guggenheim Memorial Collection. P52: Gift of the Lawrence C. Phipps Foundation. P53 (top): Funds from Helen Dill bequest. P53 (bottom): Long-term loan, Berger Collection Educational Trust. P54: Funds from the Mabel Hughes Charitable Trust. P55: Funds from the 2004 Louis Comfort Tiffany Gala (chair, table); Gift of Dr. & Mrs. John Fleming (screen). P56 (top): Neusteter Textile Collection: Funds from an anonymous donor and by exchange from Mrs. Arthur Johnson. P56 (bottom): Neusteter Textile Collection: Gift of James P. Grant & Betty Grant Austin. P57: Neusteter Textile Collection: Funds from Mrs. Simon Guggenheim by exchange. P58: Neusteter Textile Collection: Volunteer Endowment Fund and funds by exchange from Mrs. McIntosh Buell. P59 (top): Neusteter Textile Collection: Funds from 1985 Collectors' Choice. P59 (bottom): Neusteter Textile Collection: Funds by exchange from the Neusteter Institute, Mrs. Uvedale Lambert, Mrs. Ira Boyd Humphreys, and Mrs. Andrews D. Black. P62: Funds from Charles J. Norton by exchange, and funds from the Bonfils-Stanton Foundation, the AT&T Foundation, the National Endowment for the Arts, and the Douglas Society. P63: Funds from NBT Foundation, Jan & Frederick Mayer by exchange, and friends of modern and contemporary art.